HARPENDEN
HISTORY TOUR

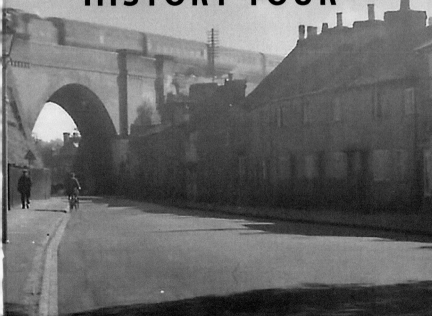

Also by John Cooper:
A Harpenden Childhood Remembered: Growing up in the 1940s & '50s
Making Ends Meet: A Working Life Remembered
A Postcard From Harpenden: A Nostalgic Glimpse of the Village Then and Now
Watford Through Time
A Postcard From Watford
Harpenden Through Time
Rickmansworth, Croxley Green & Chorleywood Through Time
Hertfordshire's Historic Inland Waterway: Batchworth to Berkhamsted
Harpenden: The Postcard Collection
Watford History Tour
Harpenden: A Village in Wartime

First published 2019

Amberley Publishing
The Hill, Stroud,
Gloucestershire, GL5 4EP
www.amberley-books.com

Copyright © John Cooper, 2019
Map contains Ordnance Survey data
© Crown copyright and database
right [2019]

The right of John Cooper to be
identified as the Author of this work
has been asserted in accordance with
the Copyrights, Designs and Patents
Act 1988.

ISBN 978 1 4456 9356 9 (print)
ISBN 978 1 4456 9357 6 (ebook)

British Library Cataloguing in
Publication Data.
A catalogue record for this book is
available from the British Library.

Origination by Amberley Publishing.
Printed in Great Britain.

INTRODUCTION

During the early part of the twentieth century, countless images of Harpenden were captured on camera by a small but dedicated group of photographers, the numerous pictures taken providing an everlasting legacy of the development from an agricultural village to the lovely commuter town of almost 30,000 people that it is today. Without the photographers' enthusiasm and commitment in recording these mostly everyday views and occurrences for posterity, much of Harpenden's pictorial history would have been lost forever.

One of the important by-products of all these images was the picture postcard, a popular and fast means of communication in Edwardian times, where a message sent by the first post in the morning was very often guaranteed to be received the same day. Using a selection of these old postcards, many of which have not seen the light of day for generations, the reader is taken on a fascinating tour around 'the Village', as Harpenden is still known to its older residents.

Many photographs were taken of the High Street and the beautiful panorama of the Common, literally the jewel in Harpenden's crown, where the eagerly awaited annual horse races were once held and children paddled in the long-gone and much-missed Silver Cup pond.

These old images also depict Church Green in those halcyon days before the First World War, when the Statty Fair arrived each year in

the third week of September to set up their swing boats, roundabouts and hoopla stalls, and more recently, the dedication of the war memorial on 9 October 1920 to the local men who had fought and died in the First World War.

Travelling up Station Road in the direction of Batford, we branch off along Marquis Lane, crossing the River Lea by the ford footbridge. Here we find Batford Mill, which was mentioned in the Domesday Book of 1086. It was one of four watermills in the parish of Wheathampstead, which included Harpenden. Today the old mill is enjoying a new lease of life as offices and industrial units.

It was at the historic Rothamsted Manor during the Second World War that one of the most clandestine activities in wartime Harpenden took place: the manor was used as a top-secret army intelligence centre that was involved in the interception of Morse code radio messages between German Luftwaffe ground stations and airfields.

As we continue on our history tour around Harpenden there is much to see, and for many, memories will be rekindled. Although no longer the quiet and peaceful village of yesteryear, it nevertheless exudes its own particular brand of charm and character with its vibrant pubs, cafés and restaurants, chic boutiques and smart shops. Despite the many changes that have taken place as part of continuing progress, the town can be justifiably proud of its heritage for future generations.

KEY

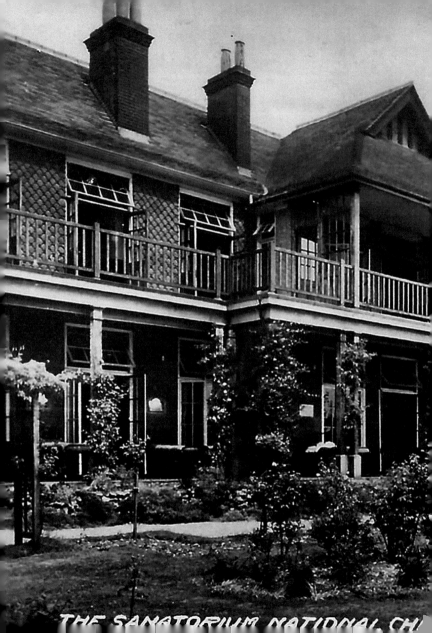

THE SANATORIUM NATIONAL, CHI

1. THE SANATORIUM, NATIONAL CHILDREN'S HOME

Our tour of Harpenden starts at the northern end of the town where this delightful building, with its distinctive veranda overlooking beautiful gardens, was purpose-built in 1910 as a sanatorium, part of the National Children's Home, for children at risk of, or suffering from, tuberculosis. Situated in the rambling countryside, a short distance from the orphanage, the young patients were often wheeled onto the veranda during the summer months as it was felt that the benefits of fresh air were deemed to aid recovery. In 1987, the King's School, an independent Christian school, took over the lovely site.

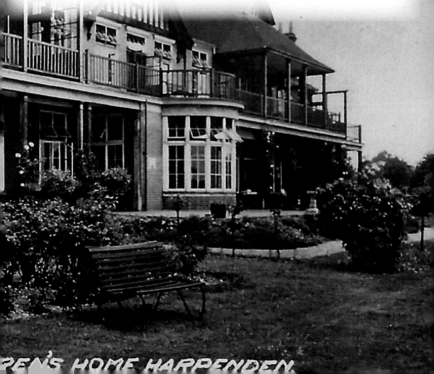

?EN'S HOME HARPENDEN.

2. THE NATIONAL CHILDREN'S HOME

A short distance from the sanatorium we discover the National Children's Home. This was founded by Dr Thomas Bowman Stephenson in 1869, initially in a small cottage near Waterloo station in London, before moving to larger accommodation in Bonner Road, Bethnal Green, two years later. In 1913, the home transferred to a 300-acre site in Ambrose Lane, Harpenden, where a large central grass oval separated the girls' houses to the left of the entrance and the boys' to the right. The whole area comprising the grounds and buildings were purchased by Youth With a Mission (YWAM), an international movement of Christians, in 1993.

3. NORTH HARPENDEN

A quiet part of north Harpenden in the early 1900s is featured here, with the prominent feature of the Luton Road Bridge, known locally as 'The Arch', in the background. The bridge was constructed in 1875 to carry the branch railway line between Harpenden and Hemel Hempstead, running a passenger service for over seventy years until its closure in 1947. During the dark days of the Second World War, the area became a hive of activity over one weekend as a combined exercise involving the local Home Guard and Civil Defence services was carried out in November 1942, watched by a team of military observers (inset), as a sustained attack was made on the bridge by the Home Guard.

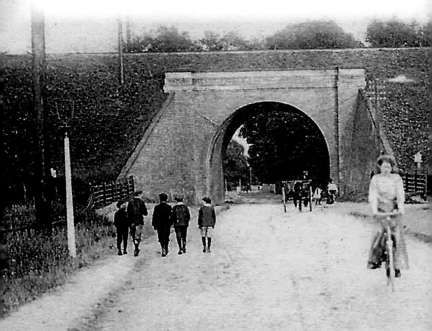

4332. 4. Luton Road, Harpenden.

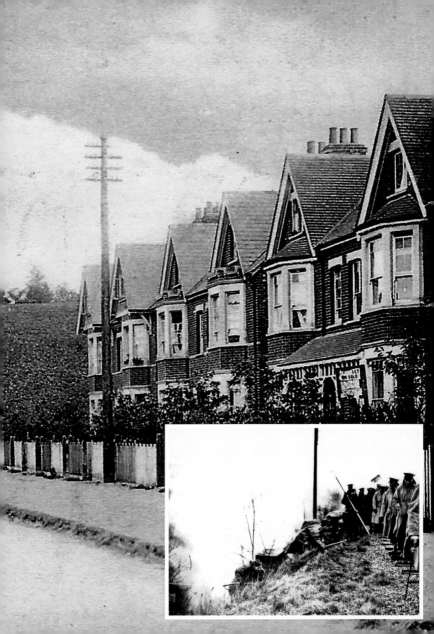

4. ROUNDWOOD HALT, HARPENDEN

A steam train is seen approaching Roundwood Halt in the early 1960s on the popularly named 'Nickey' branch line, which ran between Hemel Hempstead and Harpenden. The line opened its first passenger service on Monday 16 July 1877 and continued until its closure in 1947, although freight traffic continued over part of the route for several more years. The line finally closed in 1979. The inset photo shows part of the old concrete platform, an historic relic of all that remains of Roundwood Halt. With the railway tracks long gone, in their place is a leafy path with mature trees on either side, leading in one direction towards Harpenden and in the other Hemel Hempstead.

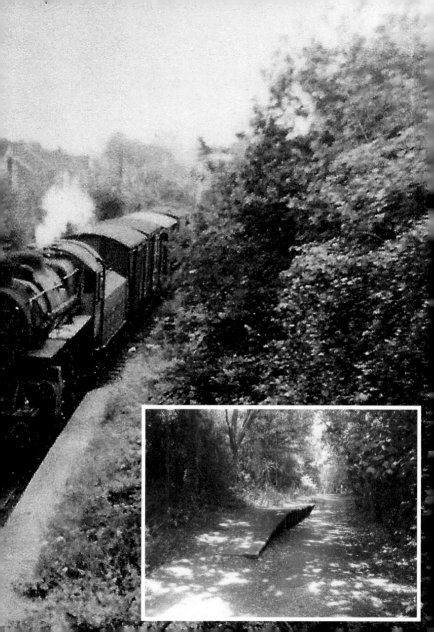

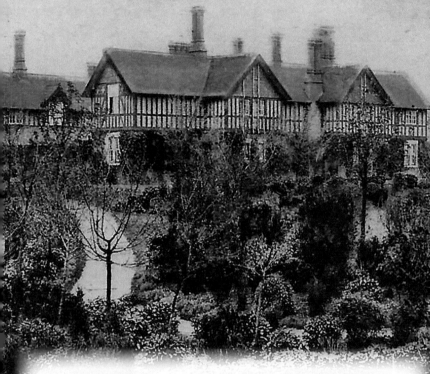

5. THE MAPLE CONVALESCENT HOME

In 1897 Sir John Blundell Maple MP, a resident of nearby Childwickbury, built the Maple Convalescent Home in Hollybush Lane. Its purpose was to serve as a home where sick employees of his furniture emporium in London's Tottenham Court Road could recuperate until their health had fully recovered. In 1929, the convalescent home was transferred to the National Children's Home and named Ackrill House, when it became the residence of retired sisters from the NCH.

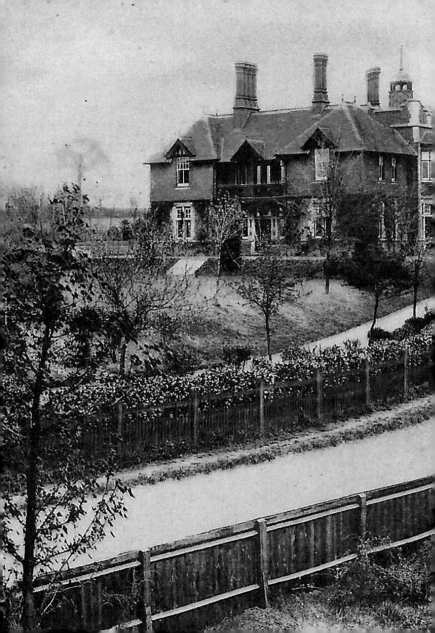

6. ST HELENA'S COLLEGE

Built in the late 1890s, St Helena's College was originally a small select school for young ladies, of which some were boarders. Sometime after the First World War the school closed and the building, which had been bought for £3,100 in 1920, became the Harpenden Memorial Nursing Centre in memory of those in the village who had given their lives in the conflict. The picture shows the front and one side of the college, which, although since demolished, has been completely rebuilt with many features incorporated similar to the original, and is now an attractive block of flats called St Helena's Court.

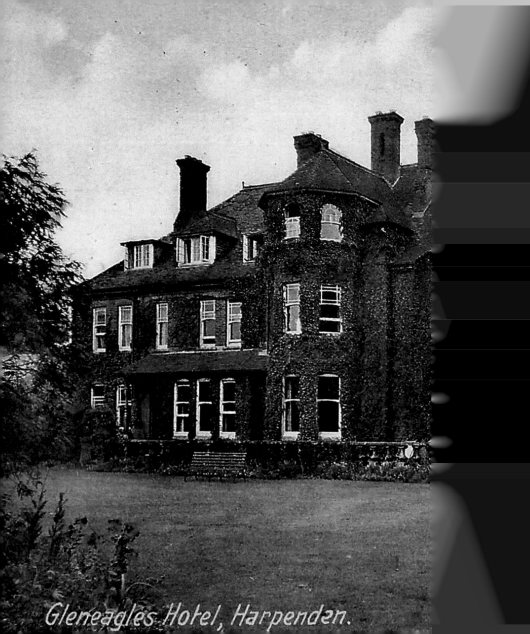

Gleneagles Hotel, Harpenden.

7. GLEN EAGLE HOTEL

At the northern end of the village where the High Street becomes Luton Road, and situated on the corner of Townsend Lane, was the Glen Eagle Hotel. The hotel was originally a large nineteenth-century house built in the 1880s for Captain Charles Braithwaite, who held several key positions in Harpenden Conservative Club. By 1928 it had become the Kirkwick Hotel, with a further change of ownership taking place in 1939 when it was renamed the Glen Eagle Hotel. By 2008 it had become the Glen Eagle Manor Hotel. Today, following demolition of the old building, a new structure has evolved that is now called Gleneagle Manor, a large complex of luxury apartments.

8. THE LOCAL BLACKSMITH

Before tarmac was introduced, a hand-operated water cart such as the one that the young lads are leaning on was used to lay the dust on the stone-surfaced roads. This cart was photographed outside the blacksmiths H. Lines, situated near the Cock Pond. The forge, which was built in 1820, closed in 1957 after being worked by three generations of the Lines family. Anvil House, a parade of shops with flats above, now occupies the site of the smithy, which was demolished in 1960 together with the houses on either side.

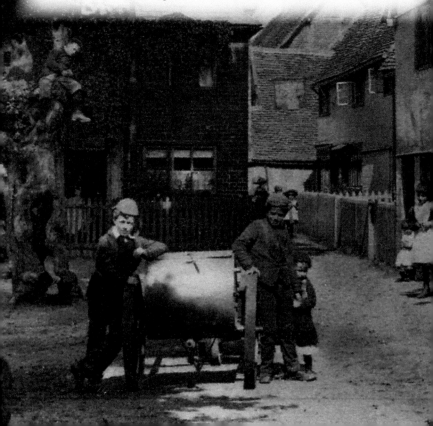

9. THE COCK POND

This charming image captured in the early years of the twentieth century portrays a view of the Cock Pond in summer, looking south along the High Street, a perfect example of the quintessential country village. Just before the outbreak of the Second World War, an air-raid shelter was constructed on the site of the now filled in pond, one of four such shelters to be built in the locality. Today, the lovely Sensory Garden featured in the inset photograph occupies the landscaped area, with the air-raid shelter, part of Harpenden's wartime preparations, now sadly no more.

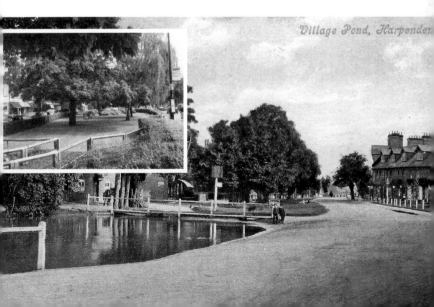

Village Pond, Harpenden

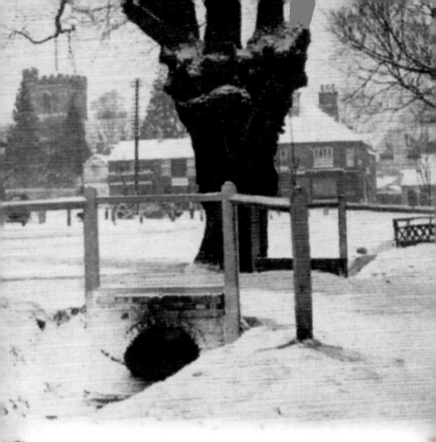

10. THE RIVER HARP

This lovely winter scene with St Nicholas Church in the background, photographed *c.* 1920, shows a brick culvert over the little stream, sometimes grandly referred to as the 'River Harp', which ran along the edge of Lower High Street from the Cock Pond to the ponds on the Common. During 1928, the Cock Pond was filled in as part of an extensive drainage scheme, and the water from the stream piped underground.

11. THE OLD COCK INN

This picturesque wintry view of the Old Cock Inn was taken outside the Cross Keys public house on the opposite side of the road by the prolific local photographer Cecil Hallam. Interestingly, two of the nineteenth-century landlords of the Cock both had additional occupations. Around 1851, Joseph Trustram, who was also a carpenter, used to hire out threshing tackle with a team of six horses to local farmers, while the landlord in the 1890s was listed as a wheelwright.

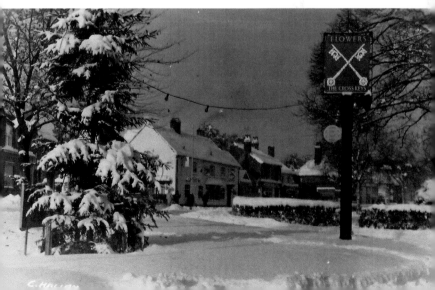

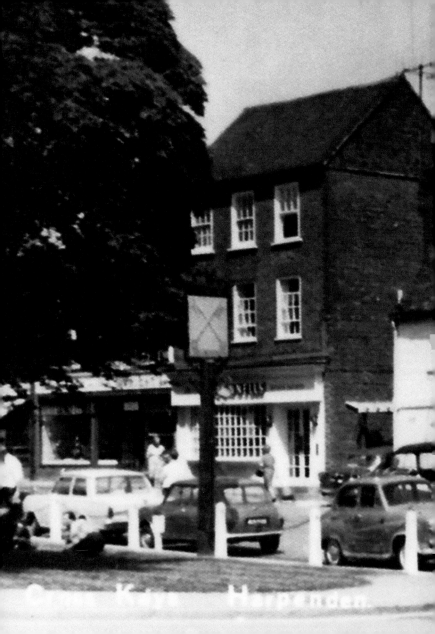

Cross Keys — Harpenden.

12. THE CROSS KEYS

Photographed in the late 1950s/early 1960s, this charming old pub, the Cross Keys, has served the local community for several hundred years, with the main bar dating back to the sixteenth century. During the 1830s, the landlord was Henry Oldaker who, with his younger brother Robert, had come to live in Harpenden in 1828. Henry was at one time huntsman to the Vale of the White Horse, but despite retiring following a riding accident, he still maintained an interest in anything to do with horses and in 1848 organised the first race meeting on the Common, an event that continued until the outbreak of the First World War.

13. THE HIGH STREET LOOKING SOUTH

An attractive Edwardian view looking south along the High Street as depicted in a postcard dated 13 July 1905. The elm trees on the right were felled in 1935 as part of a road-widening scheme.

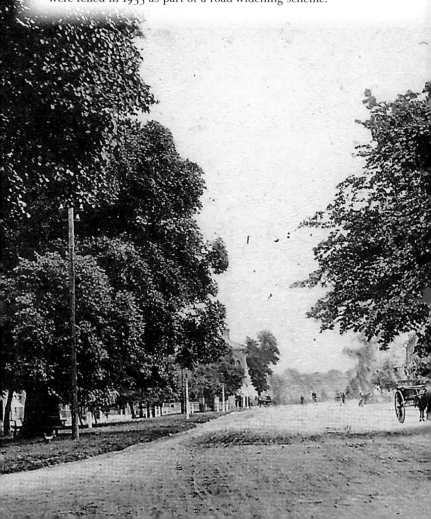

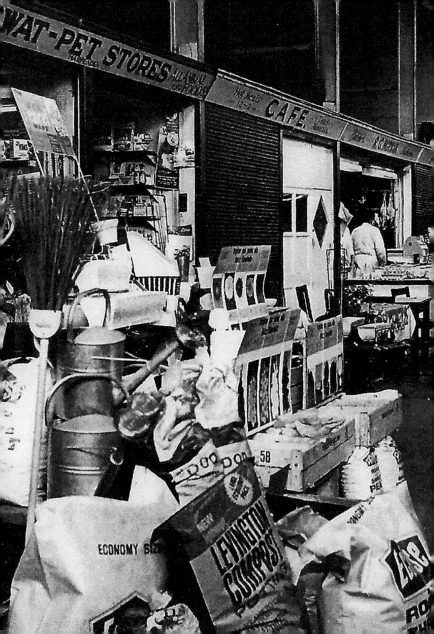

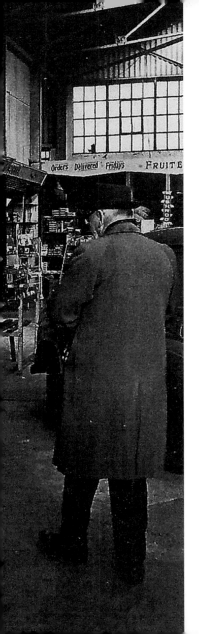

14. BROADWAY HALL INDOOR MARKET

The popular market, seen on the left in 1967 just before its closure and subsequent demolition in early 1968, opened its doors on 15 April 1933 with sixteen shop units covering a wide range of modestly priced goods and services located around the periphery of the hall. Following the outbreak of war, the hall was requisitioned by the army from the end of September 1940 for the storage of catering equipment. The market subsequently reopened to the public in December 1953.

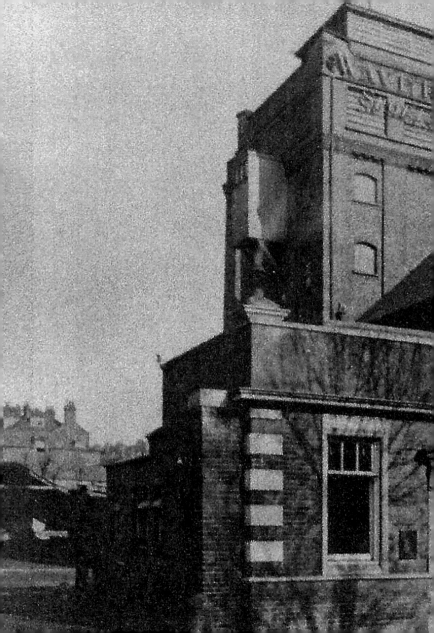

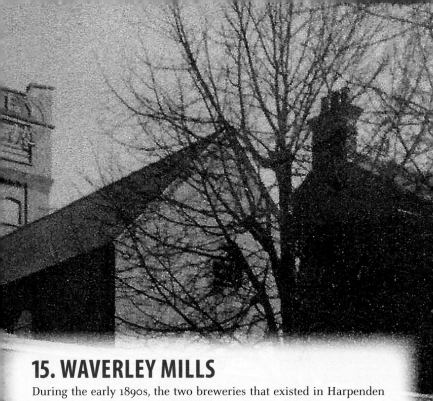

15. WAVERLEY MILLS

During the early 1890s, the two breweries that existed in Harpenden at the time, Mardall's and Healy's in Lower High Street, merged until the amalgamated brewery was subsequently bought by Richard Glover in 1897. The buildings were then modernised and the tower, a local landmark, was erected. When the business eventually closed down in 1920, the premises (now renamed Waverley Mills) were taken over by Mr George Bevins, who manufactured sportswear, hosiery and knitwear. The firm continued trading for a further sixteen years before the buildings were demolished in 1936 and a Woolworth's, Boots and Sainsbury's were constructed on the site. With Woolworth's now gone and Sainsbury's operating from further along the High Street, the building is now occupied by Harpenden Public Library.

16. RUSTIC BRIDGE

Another charming feature from the early years of the twentieth century were the little rustic bridges that spanned the small stream that ran from the Cock Pond along Lower High Street. The one pictured here was situated at the junction with Vaughan Road, where the distinctive clock above the jewellery and watchmaking premises of Mr W. Pellant can be seen just behind the bridge. With the ever-increasing growth in motor traffic, the pond became very dirty and litter strewn and eventually, in 1928, was filled in and the water piped underground to ponds on the Common as part of a comprehensive drainage scheme.

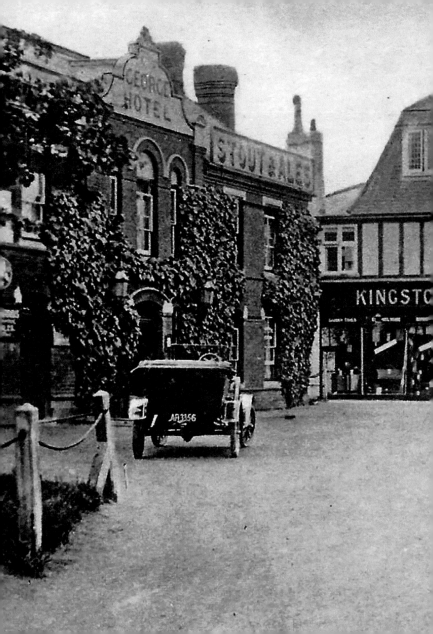

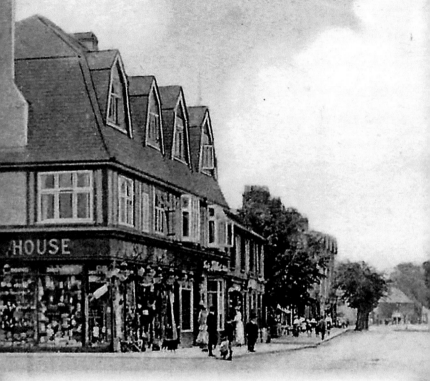

17. THE GEORGE HOTEL

This tranquil scene taken around 1920 shows the forecourt of the ivy-covered George Hotel complete with a lovely old motor car. Kingston House store is in the background and the High Street is devoid of any traffic. A familiar sight in 1920 would have been that of Mr Hammett, a fishmonger who travelled each day from Luton by horse and cart to sell his wares from a stall set up in front of the George. He later opened a shop in the High Street.

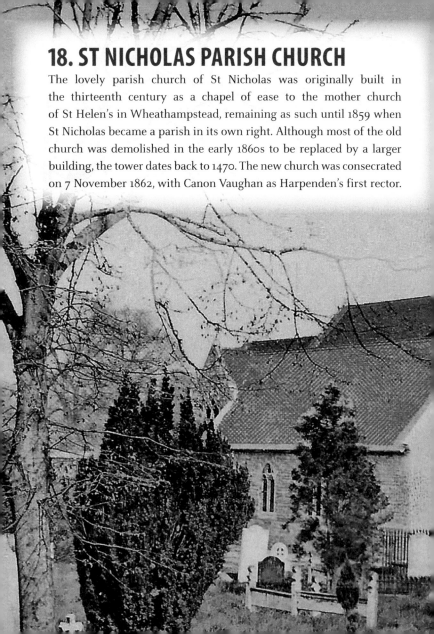

18. ST NICHOLAS PARISH CHURCH

The lovely parish church of St Nicholas was originally built in the thirteenth century as a chapel of ease to the mother church of St Helen's in Wheathampstead, remaining as such until 1859 when St Nicholas became a parish in its own right. Although most of the old church was demolished in the early 1860s to be replaced by a larger building, the tower dates back to 1470. The new church was consecrated on 7 November 1862, with Canon Vaughan as Harpenden's first rector.

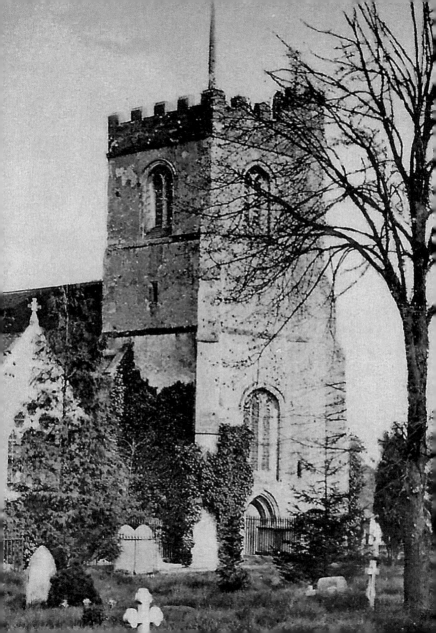

19. ST NICHOLAS PARISH CHURCHYARD

In a quiet corner of the adjoining churchyard are these Portland stone or Italian limestone headstones. These are the fourteen burials that took place here with full military honours of mostly those soldiers who had given the ultimate sacrifice in the First World War – 'the war to end all wars'.

20. FIRE!

A fascinating image from Harpenden's bygone past is depicted here in 1893 as throngs of people surge across Church Green as rival fire brigades, in accompaniment with a brass band, drive their horse-drawn appliances to Rothamsted Park to participate in various contests and sporting events.

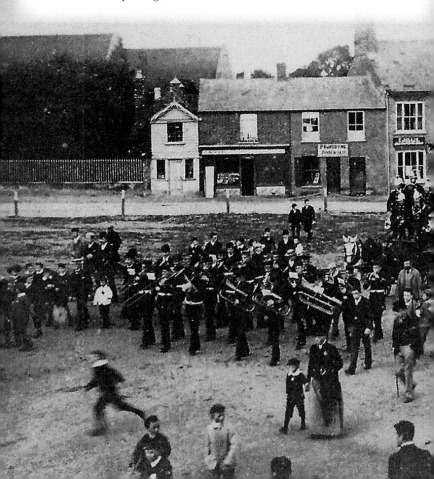

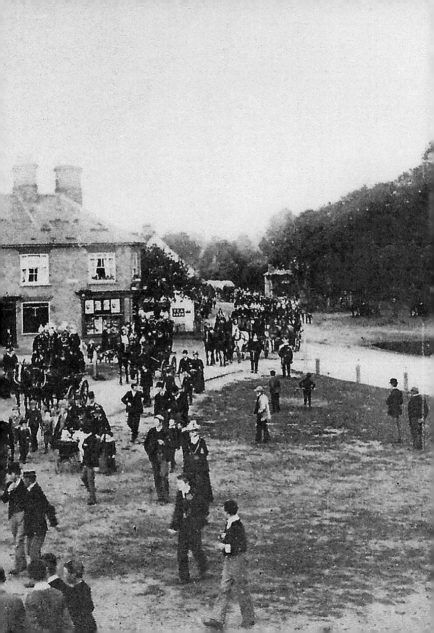

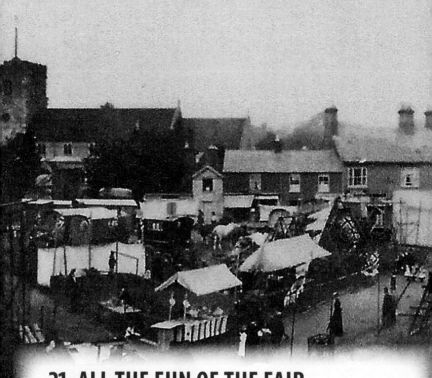

21. ALL THE FUN OF THE FAIR

During those halcyon days in Harpenden before the First World War, one of the highlights in the village that was eagerly looked forward to, especially by the children and young people, was the arrival of the Statute Fair or the 'Statty' as it was more popularly known. This annual event with its roundabouts, swing boats and various stalls took place on Church Green on the third Tuesday of September. In bygone days, the origins of the Statute Fair, also called a hiring fair, meant local employers had the opportunity to choose and recruit additional labour, such as farmworkers, domestic servants or artisans.

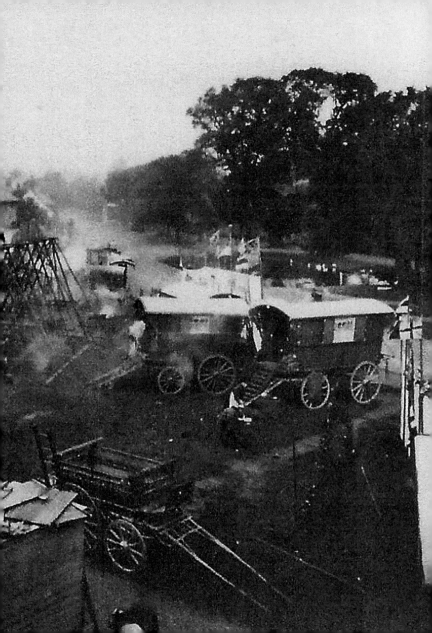

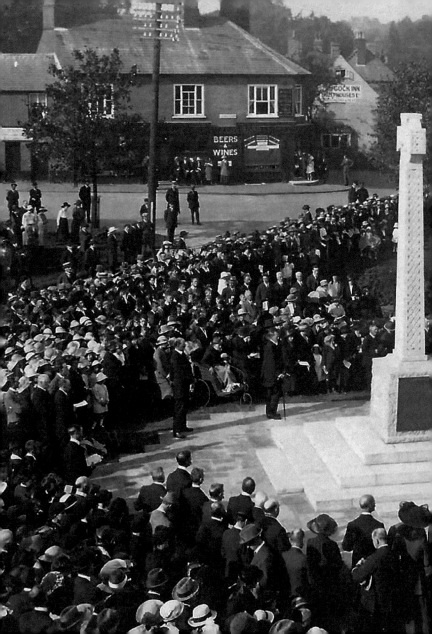

22. THE WAR MEMORIAL

On Saturday 9 October 1920 the war memorial, dedicated to the local men who had fought and died in the First World War, was unveiled at a special ceremony on Church Green by Lieutenant-General Lord Cavan. The names of the 164 men who had laid down their lives are inscribed on two gunmetal tablets on the granite Celtic wheel cross, with a further 110 names being added after the Second World War.

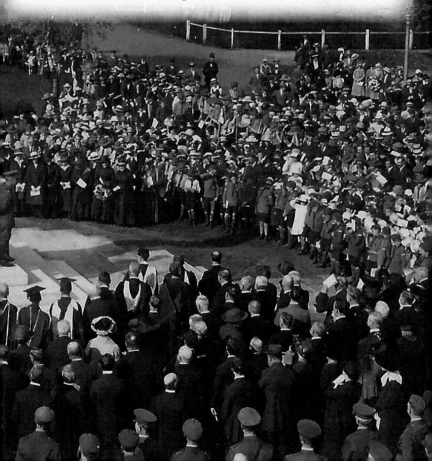

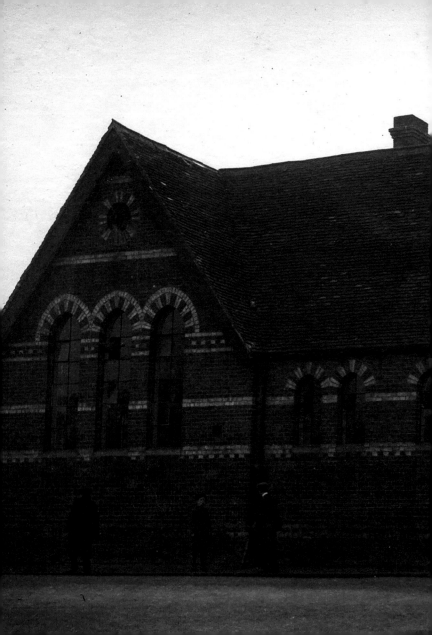

23. ST NICHOLAS' CHURCH SCHOOL

Pictured in the early days of the First World War, St Nicholas' Church School, or the National School as it was known, was originally founded in the late 1850s in a thatched cottage on the site of the present structure, which was erected in 1864, opening on 2 January the following year. During its early years, the National School had an attendance of around sixty pupils, rising to over 100 by 1870. Now St Nicholas' Church of England Voluntary Aided School, this lovely old locally listed Victorian building caters for children between the ages of four and eleven.

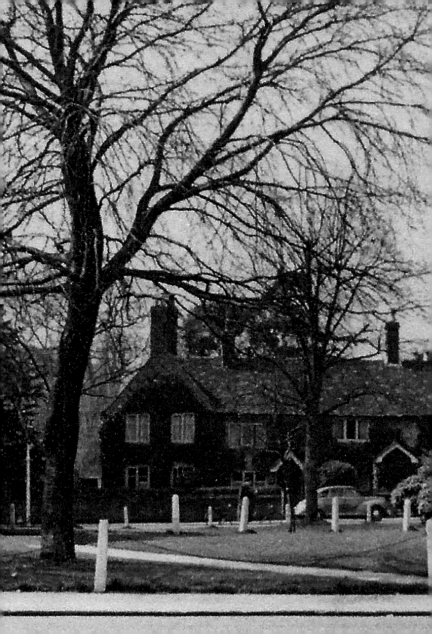

24. BATCHELOR'S ROW

Known as Batchelor's Row, these picturesque seventeenth-century cottages facing Church Green were occupied at one time or another during the 1920s and '30s by George William Curl, the parish clerk and sexton; Miss Morgan, the headmistress of the nearby Church Infant School; and the Surgery of Doctors Fraser, Maclean and Ross, to name but a few. The butcher's shop of Walter Steabben is just visible behind the war memorial. The cottages survived until the late 1950s when they were demolished to make way for a parade of shops and Harpenden's first supermarket, now occupied by Marks & Spencer.

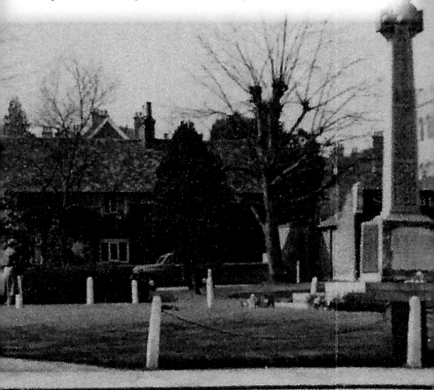

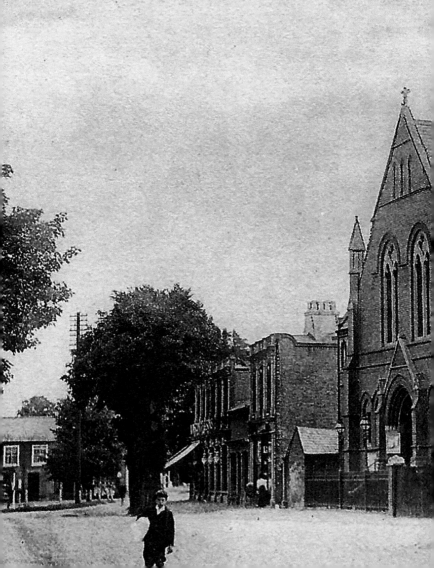

Wesleyan Chapel. Harpenden.

25. THE WESLEYAN CHAPEL

This Victorian chapel in Leyton Road was built in 1839, with services taking place there for the next forty-seven years. In 1886, a new building was erected on the same site, closing in 1930 when the new Methodist church opened on the High Street. Following extensive renovation, the old chapel was adapted to become the Regent Cinema.

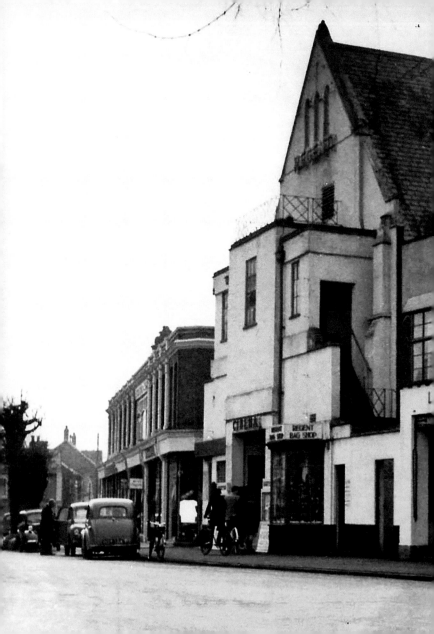

26. THE REGENT CINEMA

With the new Methodist church in Lower High Street holding its first service in September 1930, the recently vacated chapel in Leyton Road was eventually acquired by Margaret Howard, who converted it into a 333-seat cinema complete with a balcony. Following a makeover with a new white frontage and multicolour neon lighting, the Regent opened its doors with an all-British programme on 26 May 1933. The owner during the 1940s was Mr L. D. Lattey. The cinema eventually closed in September 1959, the premises being subsequently purchased by Anscombe's department store, who used the converted building as a furniture showroom.

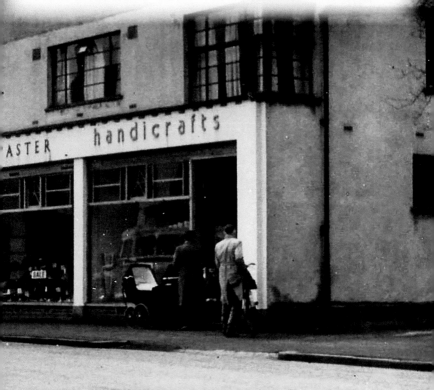

27. ANSCOMBE'S

At one time Harpenden's most prestigious shop, Anscombe's in Leyton Road exuded its own special brand of old-world charm. It was founded in 1855 by Allen Anscombe, who started trading in premises at the bottom of Thompson's Close. With the transfer of the business to Wellington House in 1874, the firm grew and over the years was extended along Leyton Road. The shop sold a variety of goods including haberdashery, linen, hosiery and menswear, as well as furniture.

Anscombe's closed in 1982 and a Waitrose supermarket now occupies the site.

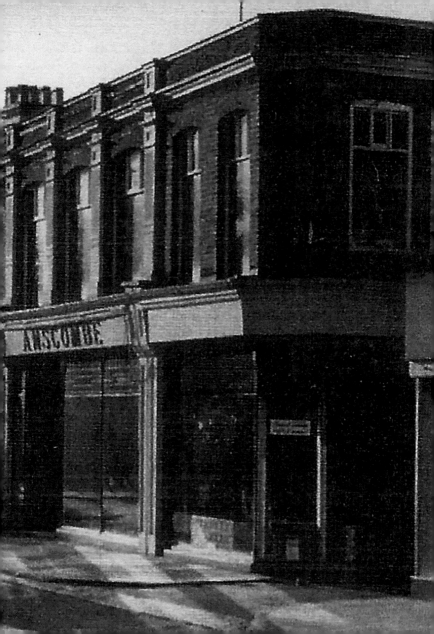

28. LEYTON GREEN

Just south of Anscombe's is an attractive open space called Leyton Green. In 1913, Harpenden's first cinema, the White Palace, occupied a position on the corner of Amenbury Lane at the junction with Leyton Road. The 450-seat theatre, subsequently renamed the Victoria Palace, was bought by Mr and Mrs Howard in 1931, who closed it two years later as being 'no longer adequate', with Margaret Howard opening the Regent Cinema further along the road. In 1939, just prior to the start of the Second World War, two public air-raid shelters, now filled in, were constructed on the Green – two of the four that were erected in the village at that time.

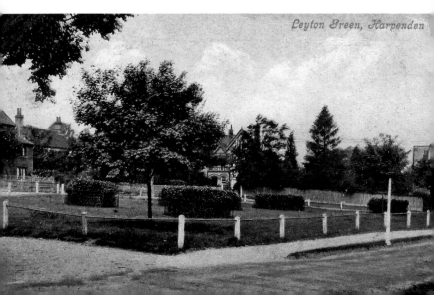

Leyton Green, Harpenden

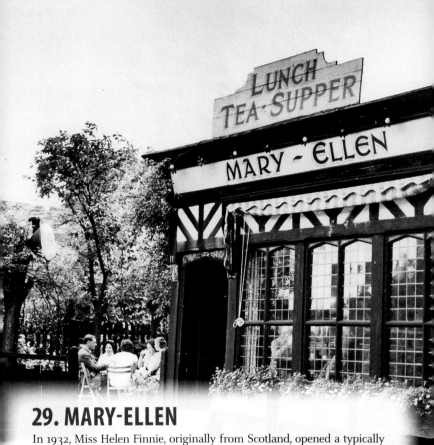

29. MARY-ELLEN

In 1932, Miss Helen Finnie, originally from Scotland, opened a typically quintessential tearoom in Leyton Road catering for the needs of her more genteel customers, offering tea, scones and delicious homemade cakes, all prepared by the proprietor. Miss Finnie retired in 1968 when the premises were then rebuilt, opening in June 1972 as the Inn on the Green.

30. PARK HALL

This historic building with its distinctive façade was constructed in 1850 by John Bennet Lawes as the British School, the first local school to provide education for the children of the local working classes. Following the school's move in 1897 to new larger premises in Victoria Road, the old site in Leyton Road was taken over a year later by the newly formed Harpenden Urban District Council for their offices and Public Hall, remaining there until 1931 when they transferred across the Common to Harpenden Hall. Today, a new building to the rear of what is now Park Hall houses the Town Hall offices, while Park Hall continues to be used for community activities.

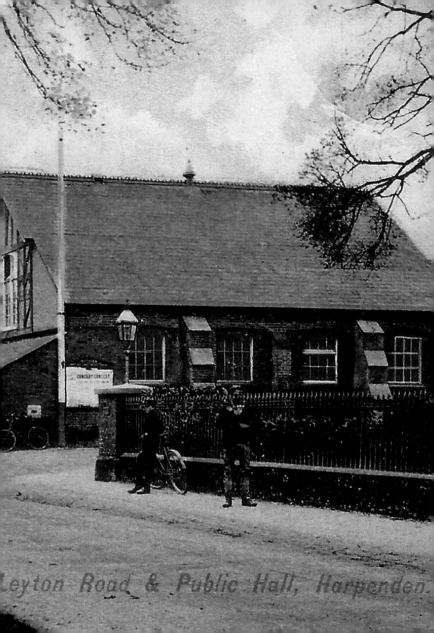

Leyton Road & Public Hall, Harpenden.

31. ROTHAMSTED EXPERIMENTAL STATION

As a young man John Bennet Lawes, who founded Rothamsted Experimental Station in 1843, became interested in the effects of fertilisers on crop growth, and together with Dr Joseph Gilbert started a series of field experiments to develop and establish the principles of crop nutrition. This image shows the old Testimonial Building that was built in 1855 by public subscription of farmers nationwide, and presented to Lawes and Gilbert in appreciation of the benefits their experiments were bringing to agriculture. Centrally featured is the Shap granite monument, which was erected in 1893 to commemorate fifty years of research.

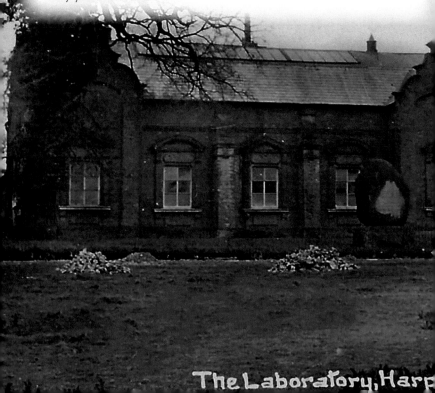

The Laboratory, Harp

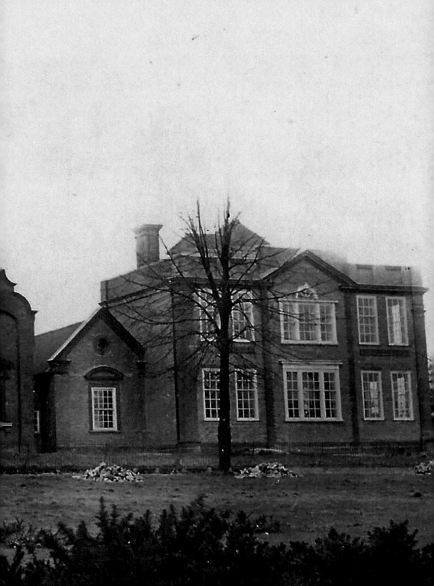

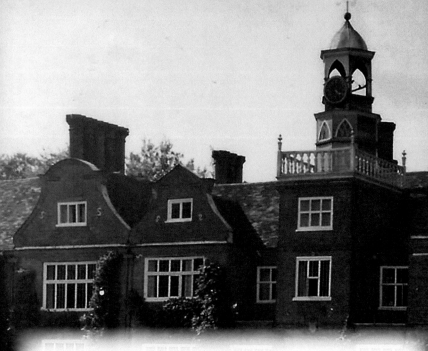

32. ROTHAMSTED MANOR

The manor was bought from Edward Bardolph in 1623 by Anne, the widowed mother of John Wittewronge (1618–93), later the 1st Baronet and the first Wittewronge to live there. Although much of the exterior dates from the seventeenth century, the framework of the entrance hall is believed to have originated in the late thirteenth century. It was during the Second World War that one of the most clandestine activities in wartime Harpenden took place. At the time, Rothamsted Manor was used as a top secret army intelligence centre, where 400 personnel were involved on the daily interceptions of Morse code radio messages between German Luftwaffe ground stations and airfields. The information was then forwarded to Bletchley Park in Buckinghamshire where teams of code breakers would process the data.

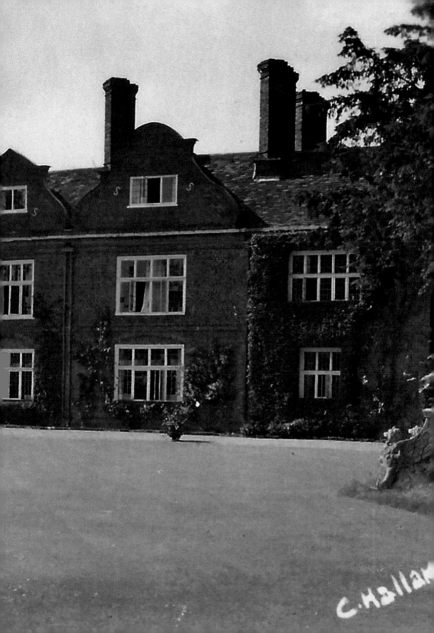

33. THE WHITE HORSE INN

This delightful 1930s image is of the seventeenth-century Grade II listed White Horse public house, which is situated on a quiet country lane on what is now the B487 to Redbourn in the small hamlet of Hatching Green, a five-minute drive from the busy centre of Harpenden. Further round the Green to the left is Manor Drive, once the main access point to historic Rothamsted Manor, where John Bennet Lawes, the founder of the Experimental Station, was born on 28 December 1814. Today, the manor house forms an integral part of Rothamsted Research, offering accommodation to visiting overseas scientists and students training on site.

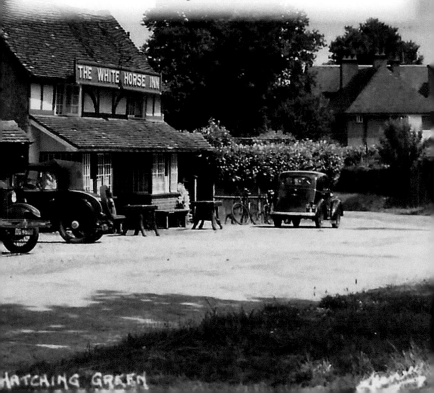

HATCHING GREEN

34. THE HERTFORDSHIRE HUNT

This delightfully English rural scene from the early 1900s shows a meet of the Hertfordshire Hunt on Harpenden Common. One of the favourite meets was on Boxing Day morning, where it must have been quite a sight to see the huntsmen in their white riding breeches and scarlet coats and the ladies looking elegant sitting side saddle, setting off at the sound of the horn on the crisp, clear air, the baying hounds eager to pick up the scent of the fox.

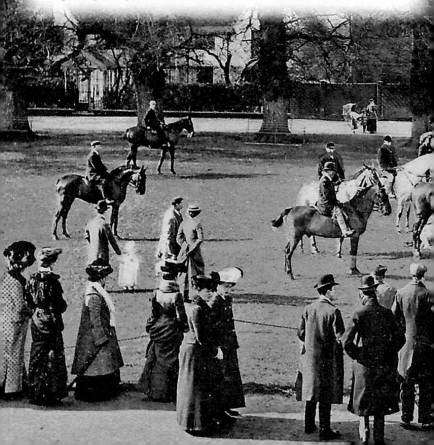

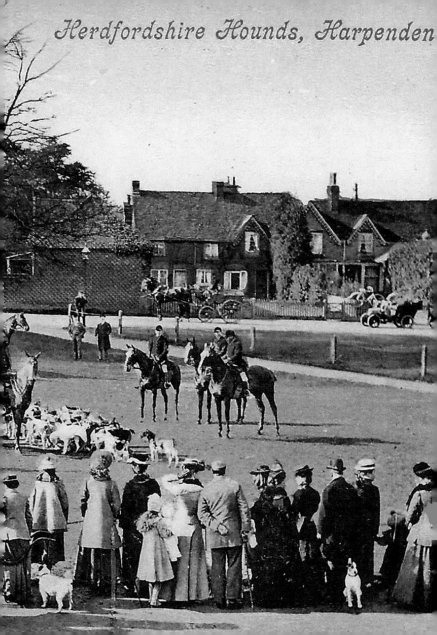

Herdfordshire Hounds, Harpenden

35. THE PUBLIC HALL

Since opening its doors in 1938, the Public Hall in Southdown Road has seen a variety of events, from the popular Saturday night dances where the young people of the day would meet and jitterbug, jive, waltz and quickstep the night away to the strains of George Mason and his band and the well-known Geoff Stokes band, to the eagerly awaited annual Scout Gang Show, where the highly versatile and very professional participants kept the audience in stitches with their extremely hilarious routines.

36. HARPENDEN HALL

Built in the sixteenth century, Harpenden Hall has seen many changes of occupancy over its long history, including at one time a private lunatic asylum and, more recently, the offices of the Urban District Council. From 1910 until 1923 the hall was a girls' boarding school, and then from 1924 until 1931 the premises were taken over by St Dominic's Convent School. Harpenden Hall is now used for office accommodation.

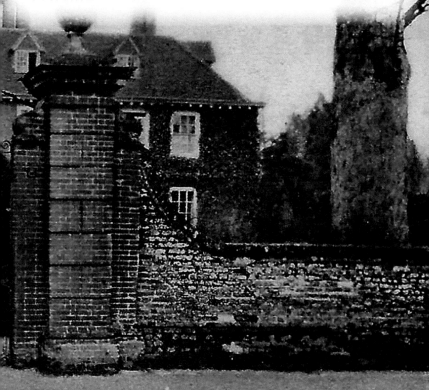

nstitute & Common, Harpenden.

37. THE INSTITUTE

The Institute in Southdown Road, or Wheathampstead Road as it was then called, opened on 10 January 1887 as the new premises for the Harpenden Lecture Institute and Reading Club. Following its eventual closure in March 1912, the building was subsequently utilised as a military hospital for several months of the First World War and used by the Territorials who were stationed in Harpenden. In 1933, the premises were sold and purchased by the Religious Society of Friends, the Quakers, in which to hold their meetings, in what is today the Friends' Meeting House.

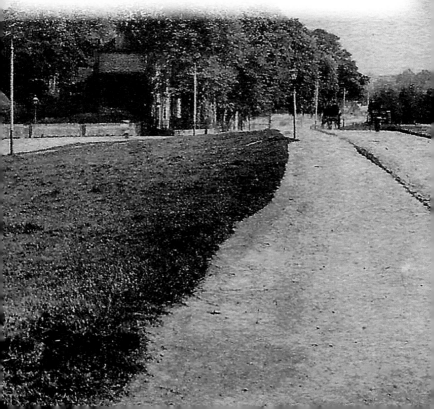

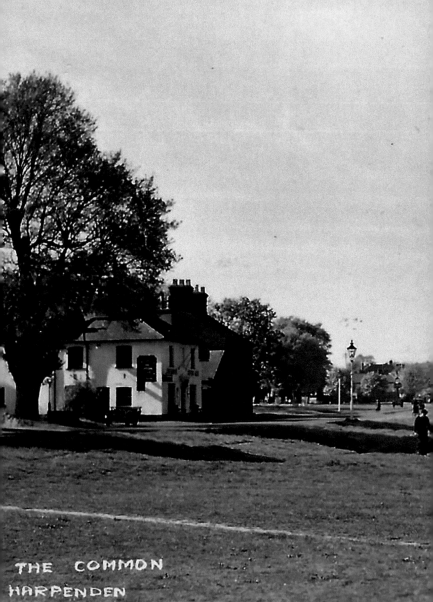

THE COMMON
HARPENDEN

38. THE SILVER CUP INN

This idyllic view shows the historic Silver Cup Inn, a lovely old coaching inn built in 1838 by the Wheathampstead brewer, John House, and situated on what is now the A1081 from St Albans on the beautiful Harpenden Common, a short distance from the village centre. The Silver Cup paddling pool and the Baa-Lamb trees can be seen on the right-hand side.

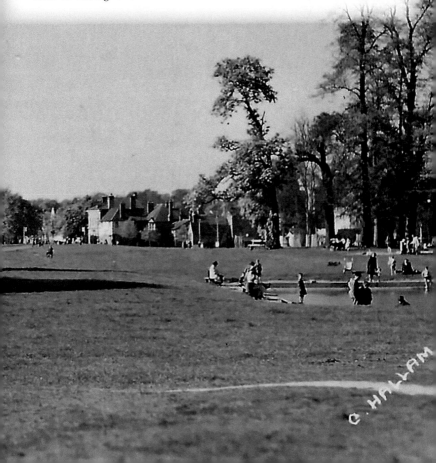

39. THE SILVER CUP POND

The Silver Cup Pond on the Common where generations of youngsters, like those seen here in this early postcard, spent many a happy, and probably very wet, hour or so either paddling or sailing a toy yacht. In order to provide a safer and more permanent environment for the countless children who flocked to the water each summer, Sir John Bennet Lawes of Rothamsted Manor had the pond concreted from its natural state in 1899, where it remained as a popular venue until 1970 when it was deemed a potential health risk and subsequently filled in and grassed over. The end of an era.

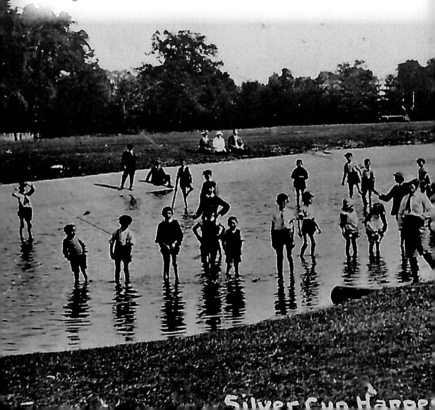

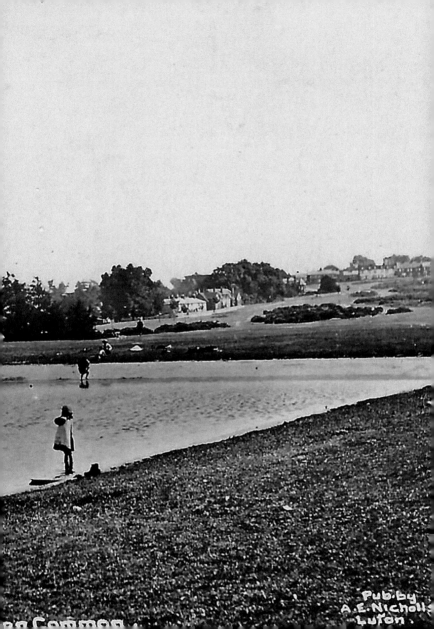

Pub. by
A. E. Nicholl
Luton.

Common.

40. 'LITTLE SWITZERLAND'

In 1928, the Urban District Council, following a review of its drainage system, decided to fill in the Cock Pond in the High Street and pipe the small stream that flowed along Lower High Street underground to the gravel pits on the Common adjacent to Southdown Road. This necessitated improving the pits (inset), which had originally been dug out in the 1870s, to form three ponds at descending levels to take the storm and surface water from the village. The project was carried out in *c*. 1929.

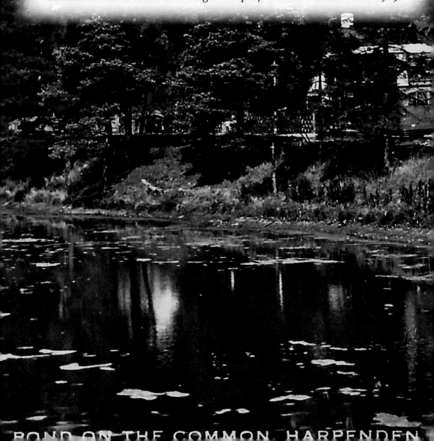

POND ON THE COMMON HARPENDEN

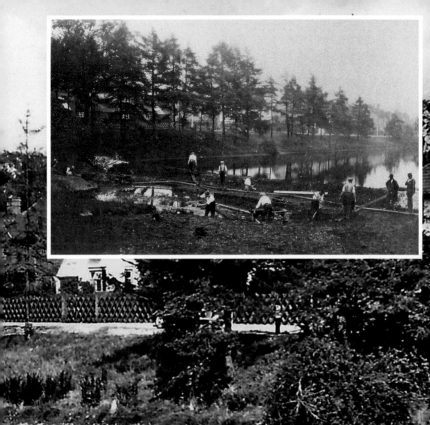
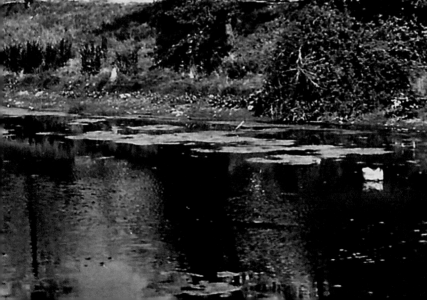

41. THE PAPER CHURCH

On the night of New Year's Eve 1905, the original St John's Church, known as the 'Paper Church' because of its timber-frame construction, caught fire, with the building being completely destroyed. The church had been erected in 1895 on the corner of what was then Wheathampstead Road, now Southdown Road, and Crabtree Lane. Following this devastating event, a new church was built a short distance away in St John's Road. The new church was consecrated on 2 March 1908, with the Crabtree Lane site being developed for housing.

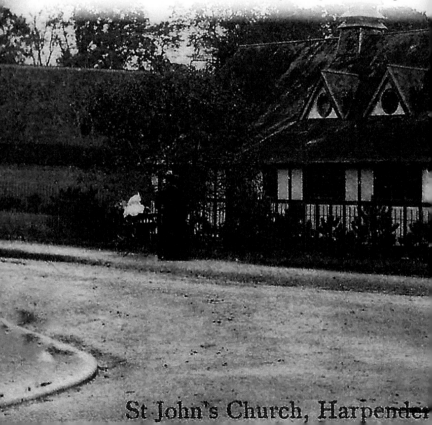

St John's Church, Harpenden

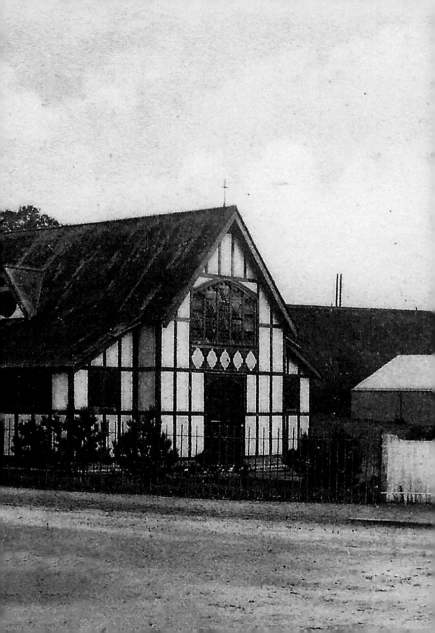

42. SKEW BRIDGE

This wonderful old picture of Skew Bridge in Southdown Road was captured at just the right time by the photographer as the London train came into view on its approach to Harpenden. The bridge, truly an engineering feat, was constructed in 1865 in preparation for the Midland Railway line that was to pass through the village, and which was opened in 1868. The old cottages on the right, which housed some of the bridge workers, were demolished in the 1960s when the site was redeveloped with modern housing.

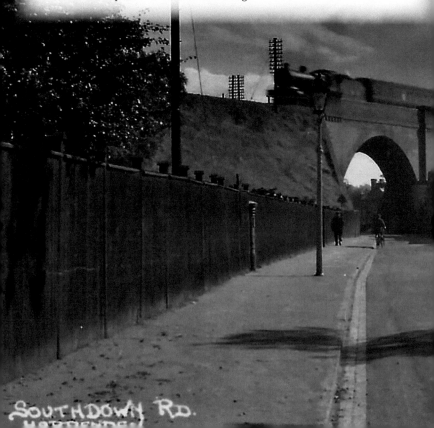

SOUTHDOWN RD.

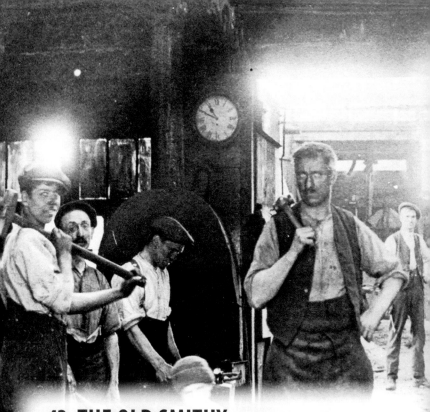

43. THE OLD SMITHY

Southdown, or the 'Bowling Alley' as it was known, is pictured (inset) in the 1880s with the blacksmith's forge of Charles Ogglesby. Following Charles's death in 1912, his son Frederick (standing next to the small boy) took over the business and before long was making and repairing bicycles to order. In the 1920s, the smithy moved to the other side of the Walkers Road railway bridge near to the junction with St John's Road, with the original site of the forge eventually becoming a thriving motor garage. The garage and the St John's Road site have now been replaced with retirement homes and a block of flats.

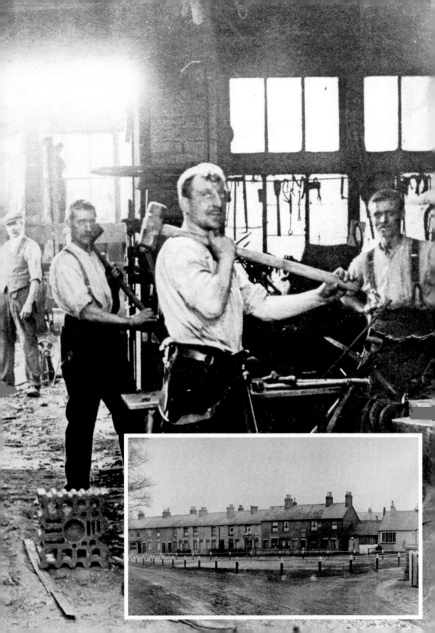

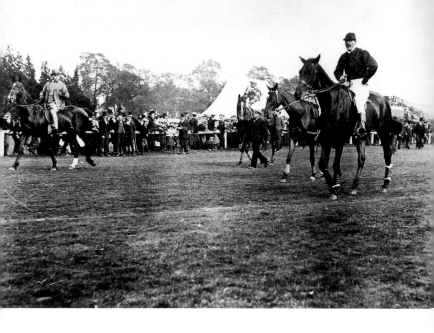

44. THE HARPENDEN RACES

Race day on the Common was a popular event that attracted large crowds from far and wide, including London. The horse races were held in May of each year during the week before the Derby from 1848 until the outbreak of the First World War in 1914. The course, which was in the shape of a long narrow horseshoe, started on the Common near to what is now the clubhouse for Harpenden Common Golf Club, crossed Walkers Road before sweeping into the country beyond Cross Lane, over the fields of the Childwickbury estate and turning near Ayres End Lane to return back again along the Common.

45. STATION APPROACH

Although the age of the horse-drawn cab was sadly fast disappearing by the mid-1930s, William Hogg and his cab, seen below waiting for a fare outside Harpenden station, was still popular for many evening commuters, who often favoured this mode of transport over the motorised taxis. William continued working until his death, aged sixty-five, in 1936. The small buildings just visible to the right of Station Approach were once the offices of several local coal merchants, but today are enjoying a new lease of life as retail units.

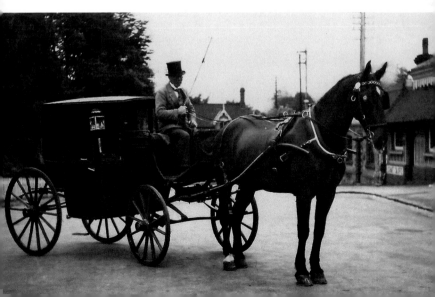

46. HARPENDEN STATION

In 1868, the Midland Railway main line extension from Bedford to London that passed through Harpenden opened its passenger service on 13 July, thus providing a direct and fast mode of travel to the capital. With the railways came growth, and in 1882 building work commenced on land that had become available when the Packe and Pym estate of over a thousand acres was sold. The first development to be built was the Park View estate, now the Milton Road area, followed by the Church Farm estate, which comprised the Avenues.

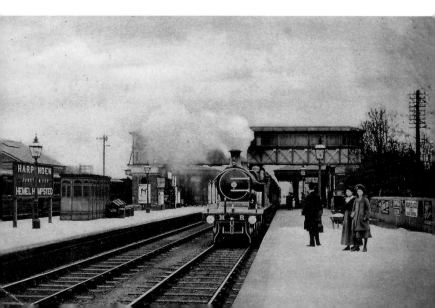

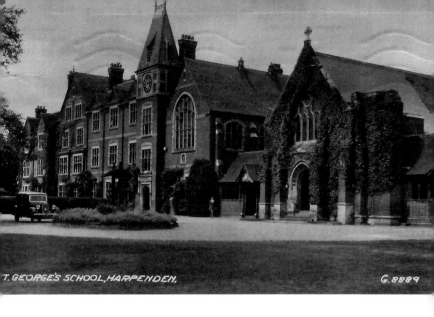

T. GEORGE'S SCHOOL, HARPENDEN.

G.8889

47. ST GEORGE'S SCHOOL

In 1885, the purpose-built school that would be St George's was started, with possession taken at the end of January 1887 under the headmastership of Robert Henry Wix. Following Mr Wix's retirement in 1904, the school buildings were leased to the United Services College, who were only in residence until 1906. The following year, the present school was founded by Revd Cecil Grant who, with his wife Lucy, had until recently been running a co-educational school in Keswick, based on firm Christian family principles. In 2007, St George's celebrated the centenary of its foundation.

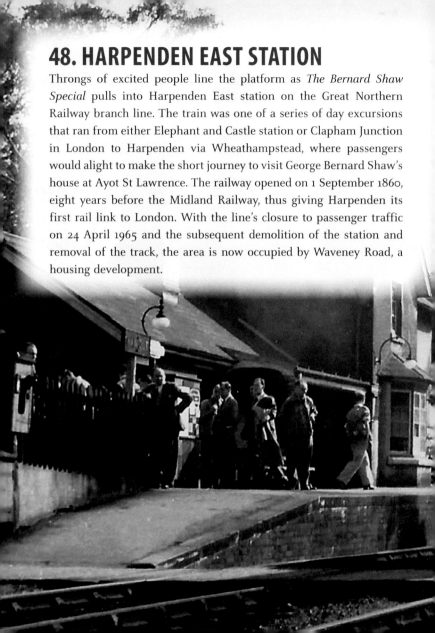

48. HARPENDEN EAST STATION

Throngs of excited people line the platform as *The Bernard Shaw Special* pulls into Harpenden East station on the Great Northern Railway branch line. The train was one of a series of day excursions that ran from either Elephant and Castle station or Clapham Junction in London to Harpenden via Wheathampstead, where passengers would alight to make the short journey to visit George Bernard Shaw's house at Ayot St Lawrence. The railway opened on 1 September 1860, eight years before the Midland Railway, thus giving Harpenden its first rail link to London. With the line's closure to passenger traffic on 24 April 1965 and the subsequent demolition of the station and removal of the track, the area is now occupied by Waveney Road, a housing development.

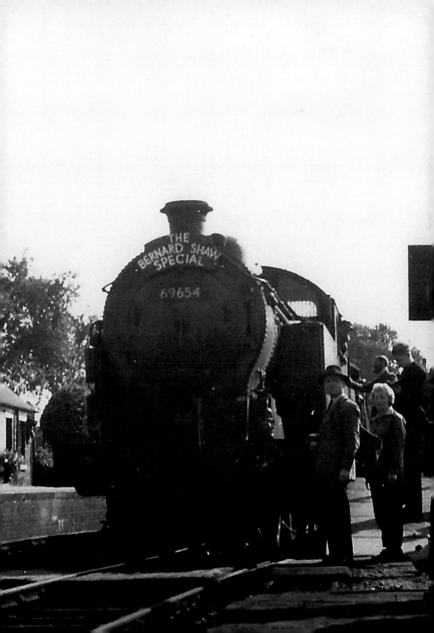

49. THE THATCHED COTTAGE

A short distance from the Marquis of Granby Inn across the River Lea near Batford Mill are the lovely old seventeenth-century thatched cottages as featured in the photo here from *c.* 1925. Originally there were three dwellings, but these were amalgamated into one in 1958. Earlier occupants of the cottages included an agricultural worker and William 'Shep' Arnold, a local shepherd who lived there with his large family. Each day he herded his flock from Mackerye End Farm to the Common by way of Crabtree Lane. Life in the cottages at the turn of the nineteenth century was very hard and basic. There was no indoor sanitation and water for washing had to be drawn from the nearby river. A spring close by provided the drinking water.

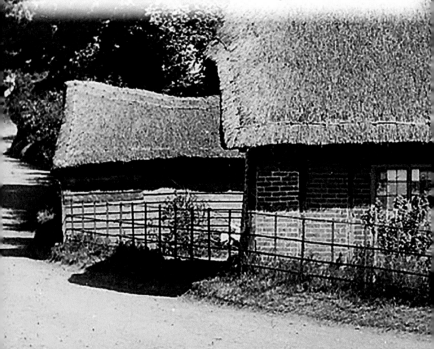

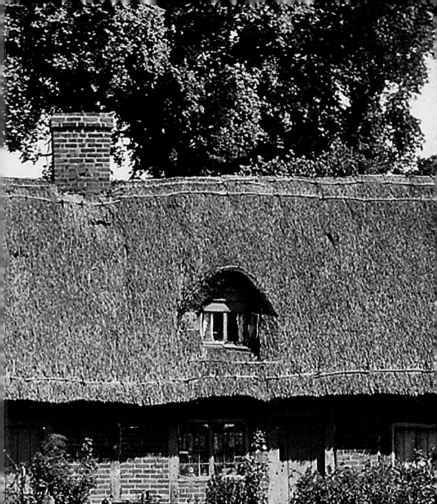

50. BATFORD MILL

Batford Mill is depicted below in a photograph taken in the late 1930s. The mill was one of four in the parish of Wheathampstead, which included Harpenden. Today the old mill has been completely renovated and is occupied by offices and industrial units (inset). There is little evidence now to show where the River Lea once flowed, as it was diverted from its original course through the mill in 1954.

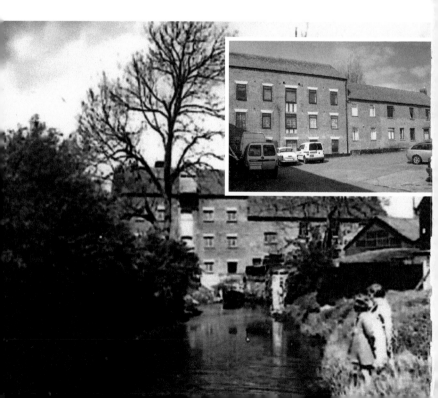